With ♡

[signature]

The Slow Down Book
A Pathway to the Fullness of Life

Text & Illustrations by Jessel Miller

10 9 8 7 6 5 4 3
Editing by Carolynne Gamble
Typography & Layout by Waterford Graphic/ Design
Printed by Tien Wah Press, Malaysia

The Slow Down Book may be directly ordered from
Jessel Gallery
1019 Atlas Peak Road
Napa, Ca 94558

www.jesselgallery.com . jessel@napanet.net
tel 707-257-2350
fax 707-257-2396

Publisher's Cataloging-in-Publication
(Provided by Quality Books, Inc.)

Library of Congress Control Number: 2003116973
Miller, Jessel
The slow down book: a pathway to the fullness of life/
story and paintings by Jessel Miller.

p. cm.
ISBN 0-9660381-2-6

1. Conduct of life. 2. Quality of life. 3. Conduct
of life--Religious aspects. 4. New Age movement.
I. Title

BF637.C5M55 2004 158
 QB133-1670

A Pathway to the Fullness of Life

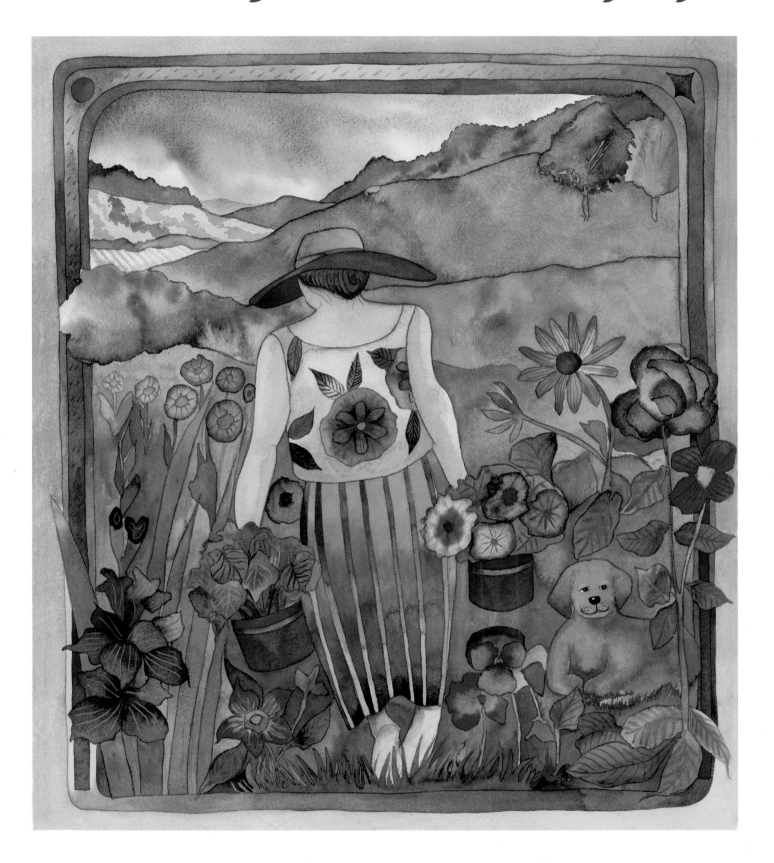

The *Slow Down* Book

Story and Paintings by Jessel Miller

Jerry Jessel
December 8, 1918 - March 19, 2003

It took the death of my mother to refocus my inner vision and re-establish the course of my life. I realize daily the powerful light she is in my heart and what an inspiration she has been to my whole family.

The Slow Down Book is dedicated to Mom who celebrated each day with gusto and joy. She instilled a fearlessness in me, a shy, awkward child who turned from a cocoon into a butterfly.

I thank the Amadeus Spa at the Marriott Hotel and Ristorante Allegria in Napa, California. Both establishments welcomed me with open arms and allowed me to work on this book in peace. Thanks also to my personal trainer, Ann Yates who gently guided me back to physical health.

I thank my son, Ryan Miller who took the lead as Jessel Gallery manager and gave me the time I needed to focus completely on the creation of this book.

And finally, I thank my editor and friend, Carolynne Gamble and my new friend, JoAnn Deck. Our journey together has brought me to a place of Zen.

Stop Before the Bough Breaks

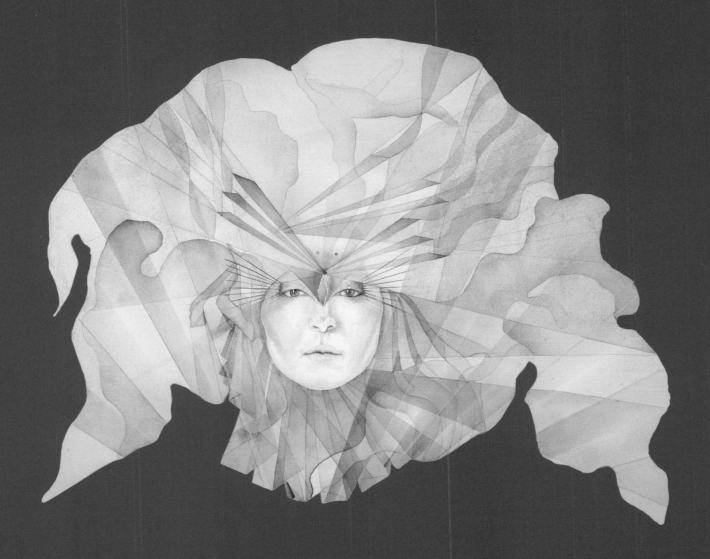

While racing down a country lane,
Faster than a speeding train,
I heard two Angels in my ear
They said, "Sweet thing come over here."

"This constant rushing is no good.
You need to rest you know you should."
I laughed and said I could not stop,
Art to create and floors to mop,

People to see and places to go,
Calls to be made no time to go slow.
Didn't they understand my plight,
Working to make all wrongs right?

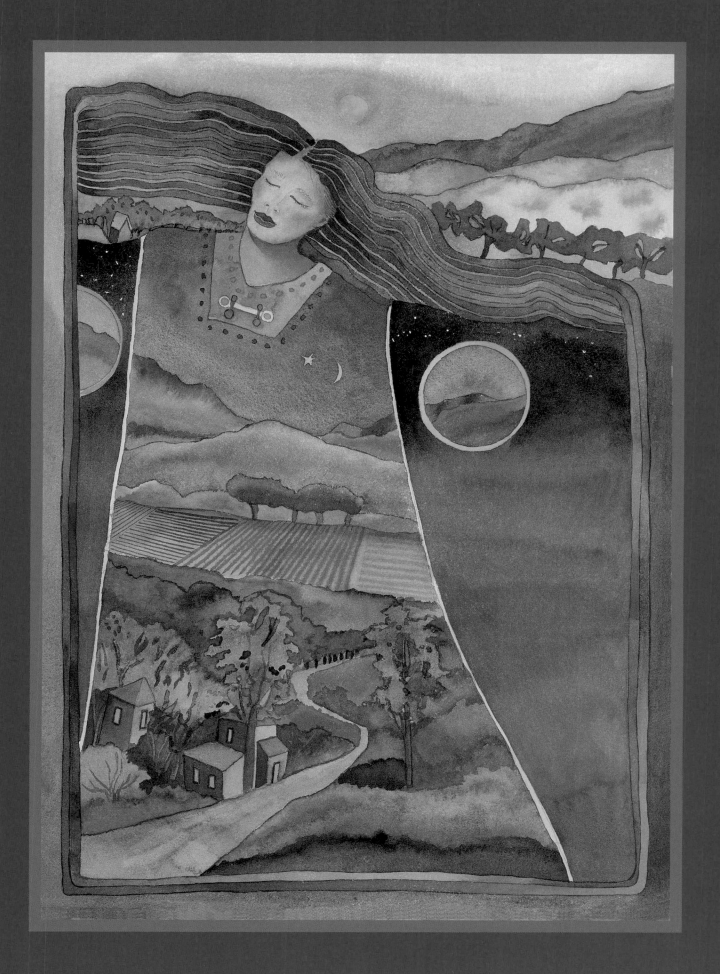

Their wings fluttered as they took my hand,
"We'll take you now to Slow Down Land."
I knew I was tired and stressed inside
So I followed and let go of my pride.

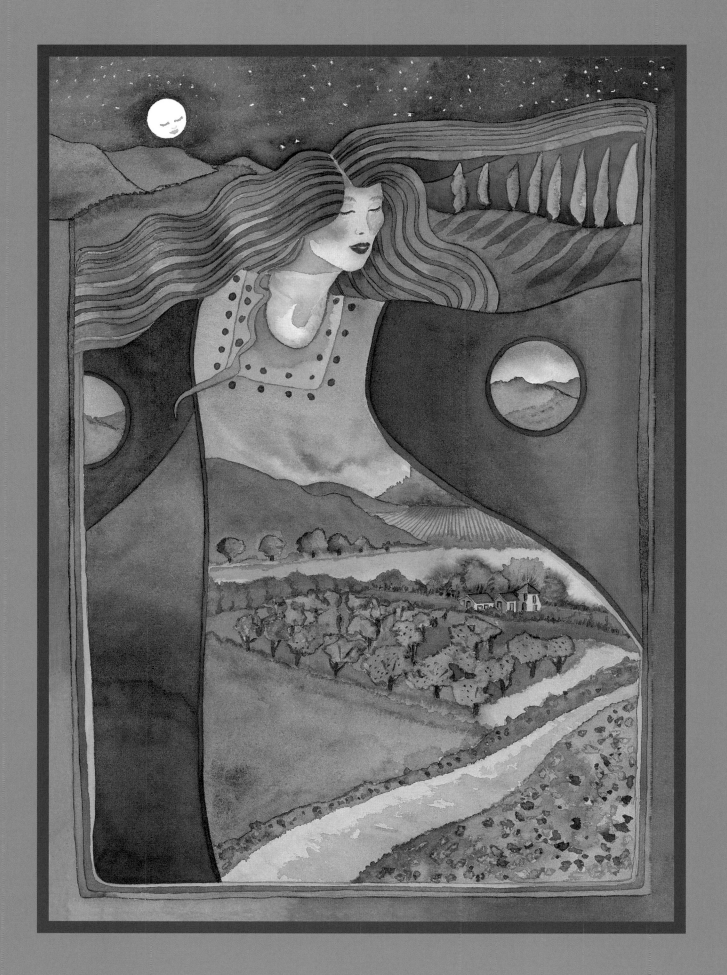

"We'll show you what you need to do
To live a life that's truly you
Simple and slow as life is meant
We'll show you with your clear intent."

"You can find all that you seek
Rest your head upon our cheek"

"Now quiet still your beating heart
Here is where this book will start."

Be Gentle with Your Spirit

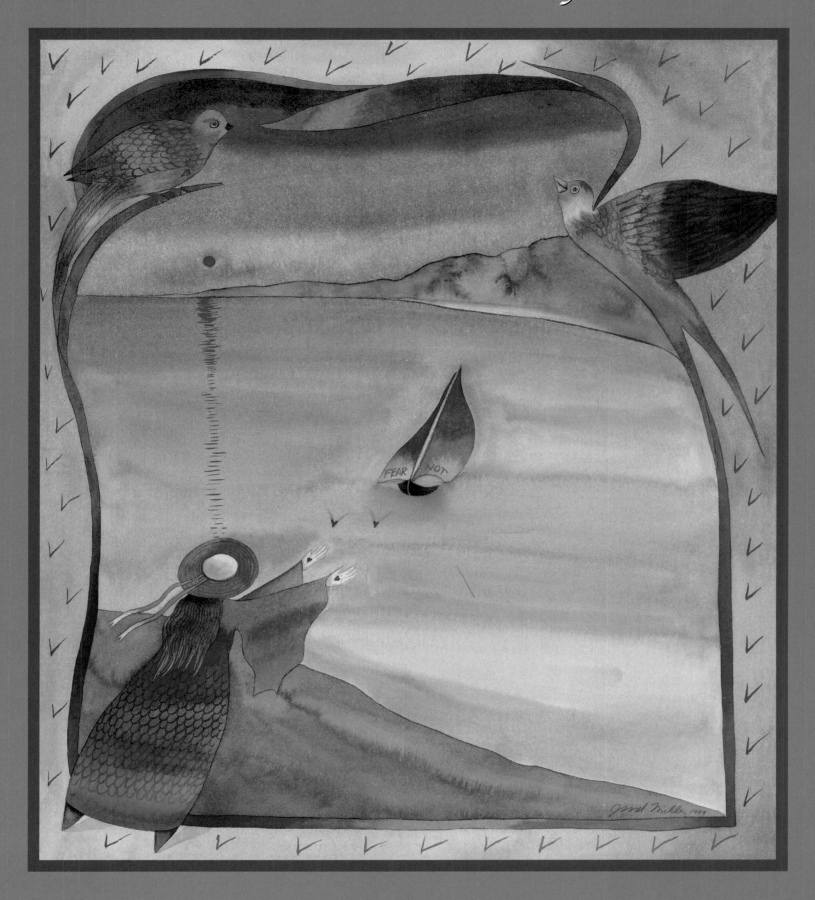

A stillness envelops me and the chatter in my mind ceases. The Angels, Ease and Grace, seem to understand that inside we all hear many voices - reactions to the stress and strain of our daily existence. They take me to a hammock by a running stream and as I feel the wind move me back and forth, I hear them whisper, "Listen now to the sounds around you. The birds wake the world every day. Their sound, like a silver thread, weaves across the whole planet. They are nature's chimes. You are our precious child. Rare and royal."

"In Slow Down Land, we remind you to start each new day with a clean slate, a clear and open mind and remember to float."

Finding Heart Rocks

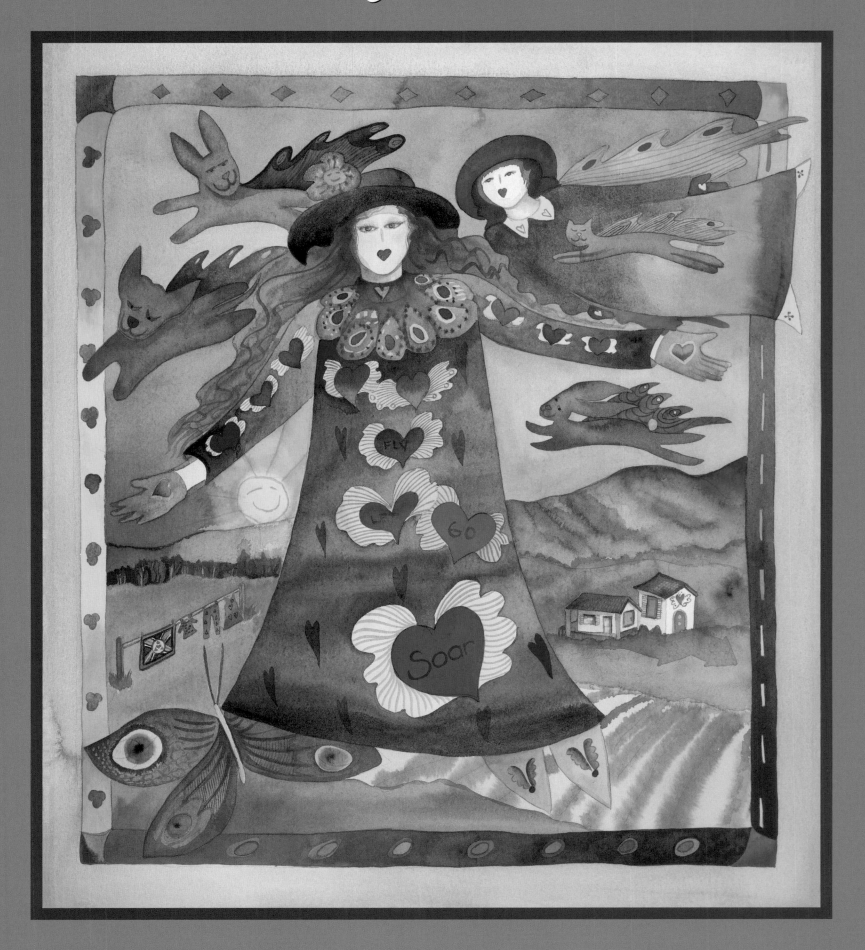

"What do you have in your hands?" I ask as the Angels lift me to my feet. "We have a gift for you. The earth holds so much power, we found these lying on the shore right beside you."

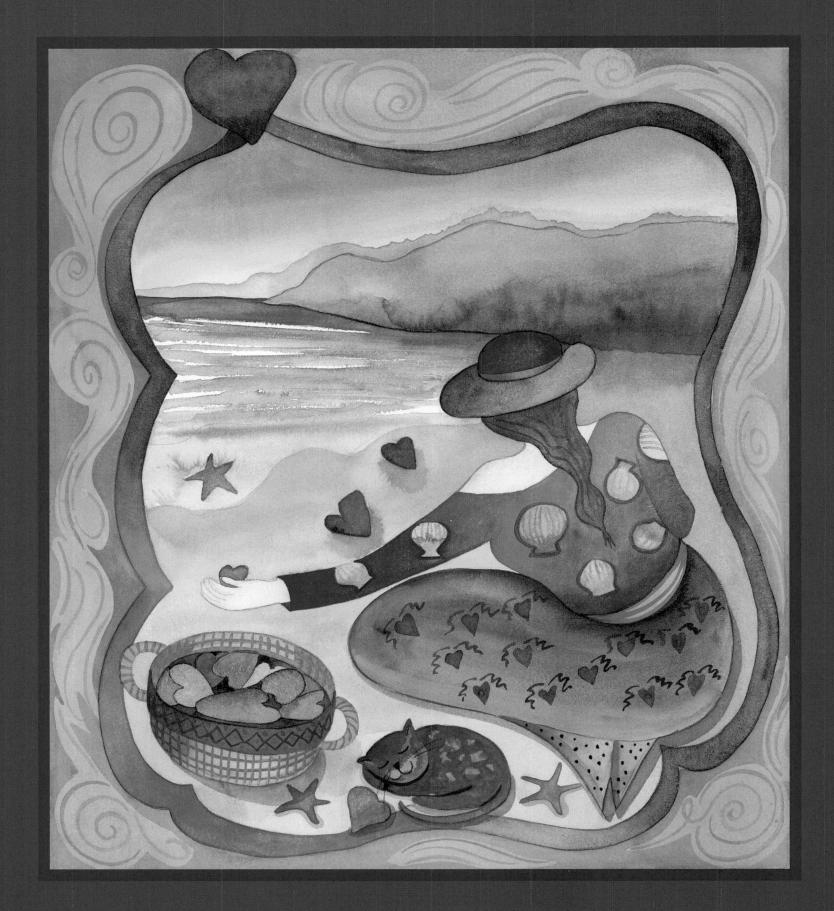

I look as they unfold heart rocks in each of their hands. "These represent our eternal love in your life and they are reminders that you are rich in the amazing friends you surround yourself with. Each smile you give to another person is returned ten fold."

"As you share your beauty you exude from inside out. Through your whole being, energy radiates to the world around you. We whisper our prayer in your ear."

Return to the Old Ways

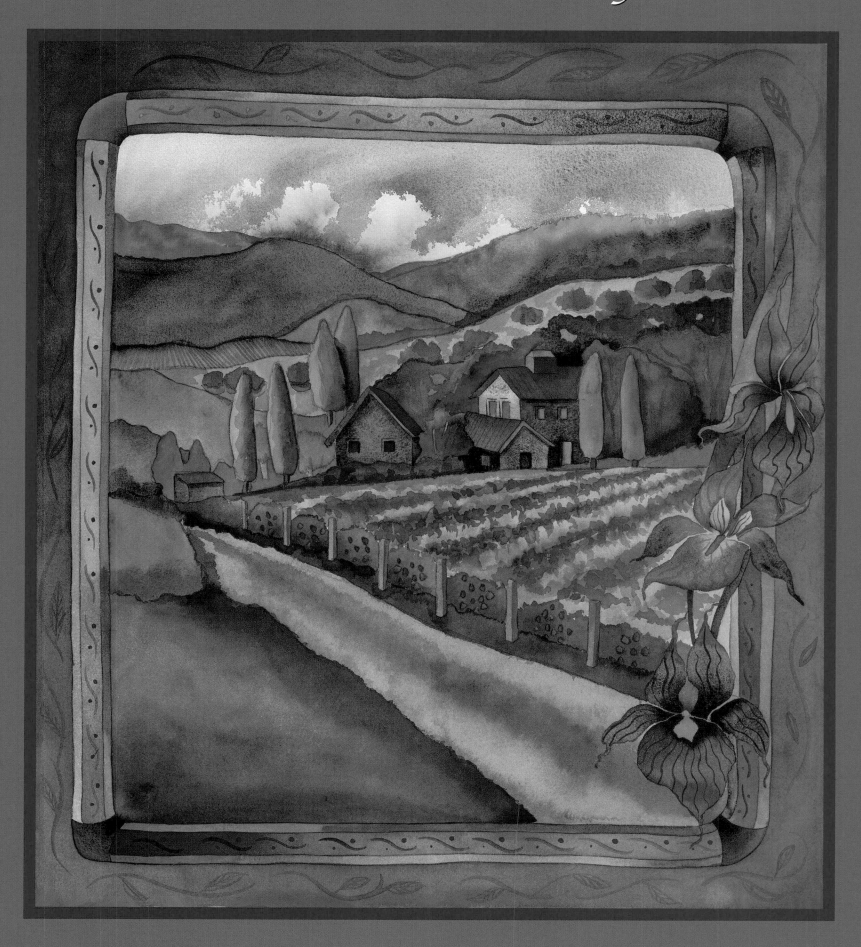

"Our prayer is that we return to the old ways of respect, kindness and consideration.

The small town ways of deep devotion to family, growing in the garden, touching the earth with our bare hands and appreciating the sheer beauty of life."

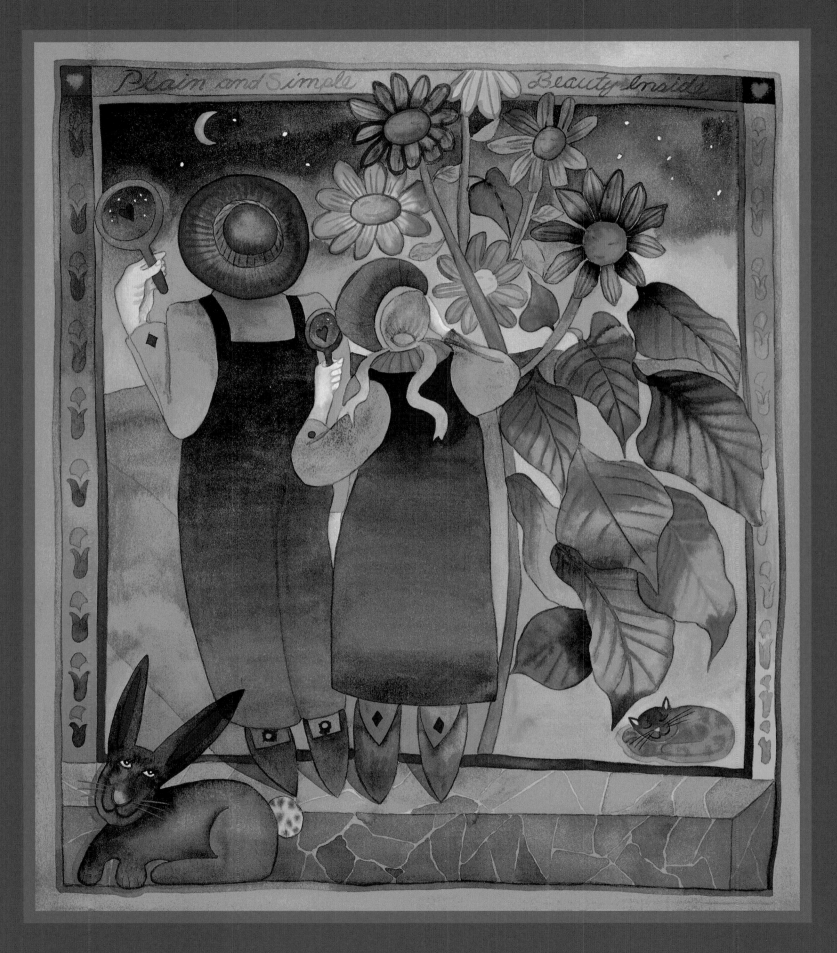

"Let us come together by the Love which weaves us all into a Universal Tapestry."

The Purr is the Cure

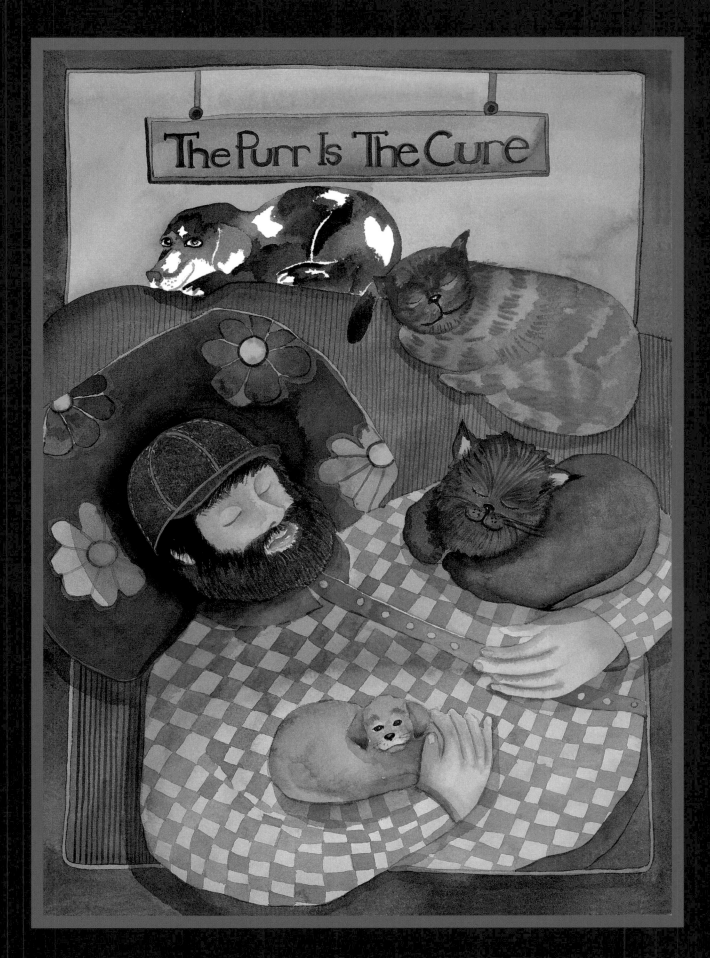

We begin to walk a path edged in wild flowers and lavender. Grace lifts a kitten to my arms and reminds me...

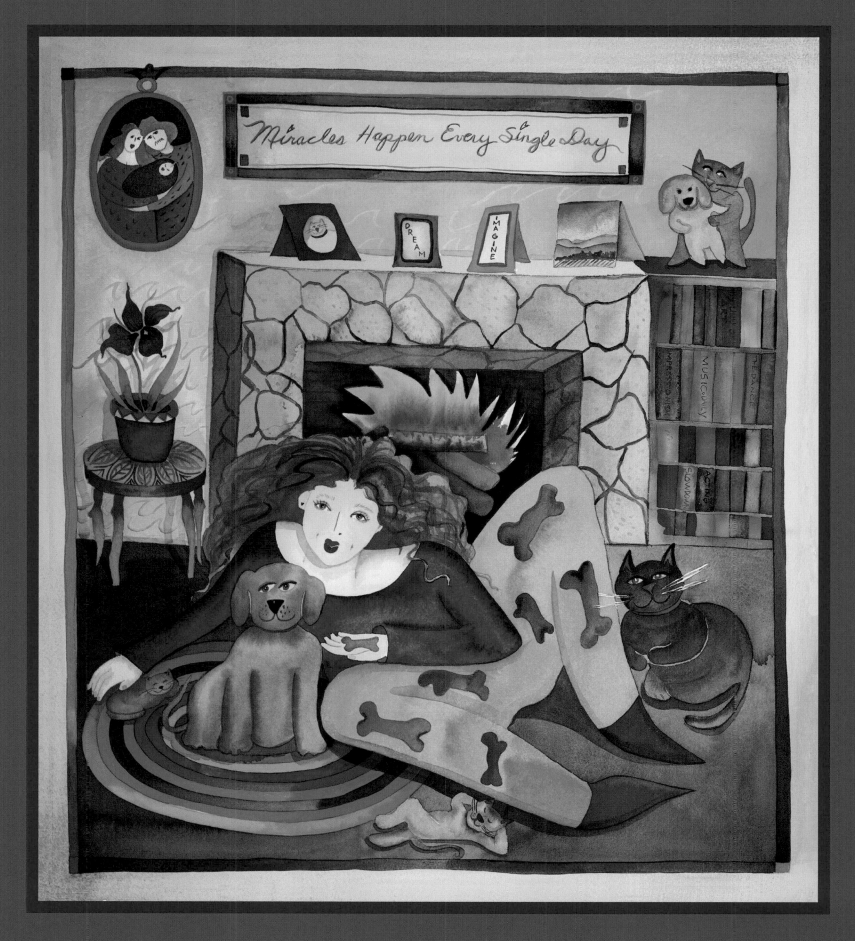

"These creatures say in their souls, all the words humans choose to profess their love. The difference is that animals are ever-loyal. It does not matter what is said or where you live or what you own. Money means nothing and clothes do not impress them. They give unconditional love, constant and true."

I think of my animals with new respect.

Diet of Honest Food

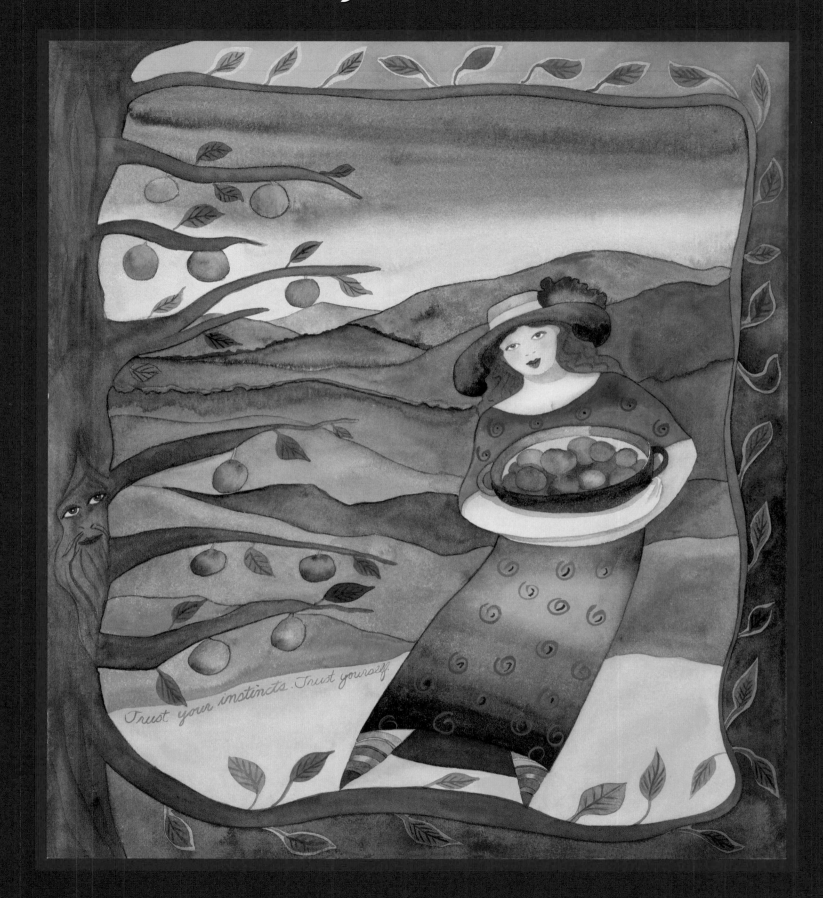

We arrive at a lush vegetable garden. There is a family of butterflies swirling in the air above us. Messages flutter down into my eyes.

"The earth is our greatest miracle next to life itself. From the rich soil, the gift of life begins with seeds planted. All you need comes directly to you unprocessed, naturally flavored, raw and whole. Eat of your garden, drink of clear water, taste your fruit and nuts. Sprout your seeds."

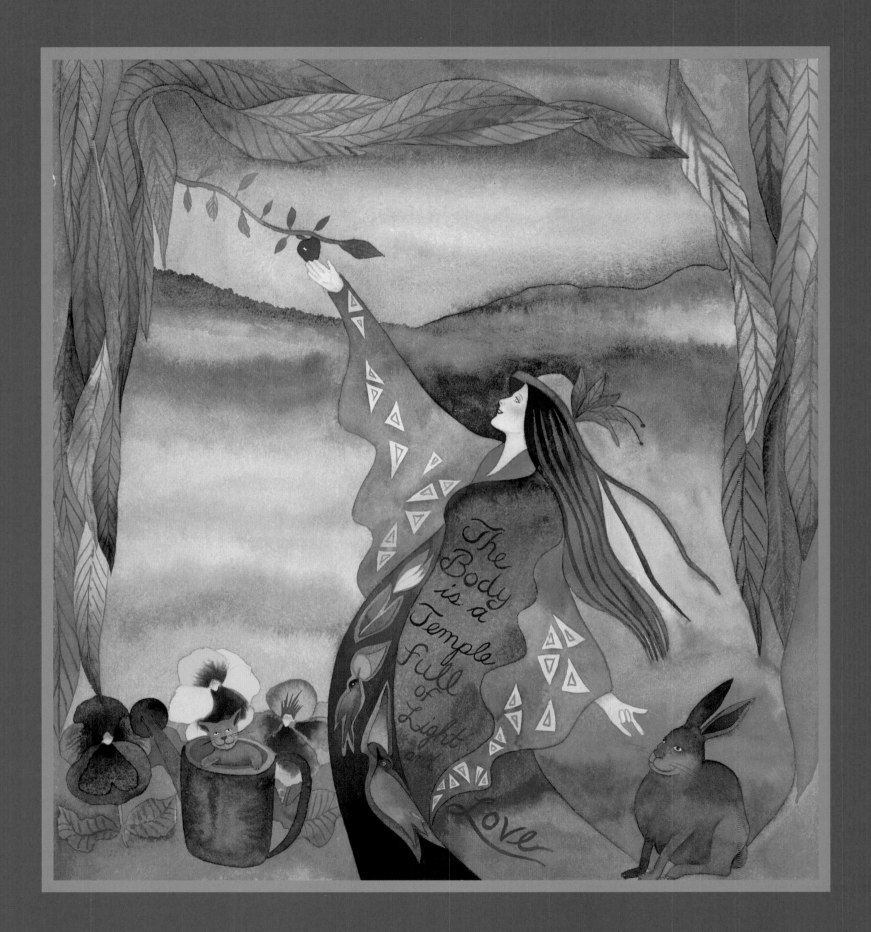

"Sometimes you have needs. Comfort foods seem to soothe you when life hands you misfortunes. Partake sparingly of these treats, yet remember that they are always there for you. Follow this path daily and your reward will be a healthy life."

"Your body is a temple full of love and light. Our best advice is to start slowly moving every part of your body every day."

Create Beauty

Ease guides me to my home and my painting table, to my piano and my living space. "Look around you precious person. In your hands, through your fingers, there is magical color. In your voice music is heard. When you move, swans watch and smile. You are a beam of brilliant light needing to share and shine out to the world."

"Now, today, this moment is your time on this earth. Create beauty on your path, and the world around you will experience your stillness and be calmed by your presence."

By Hand is By Heart

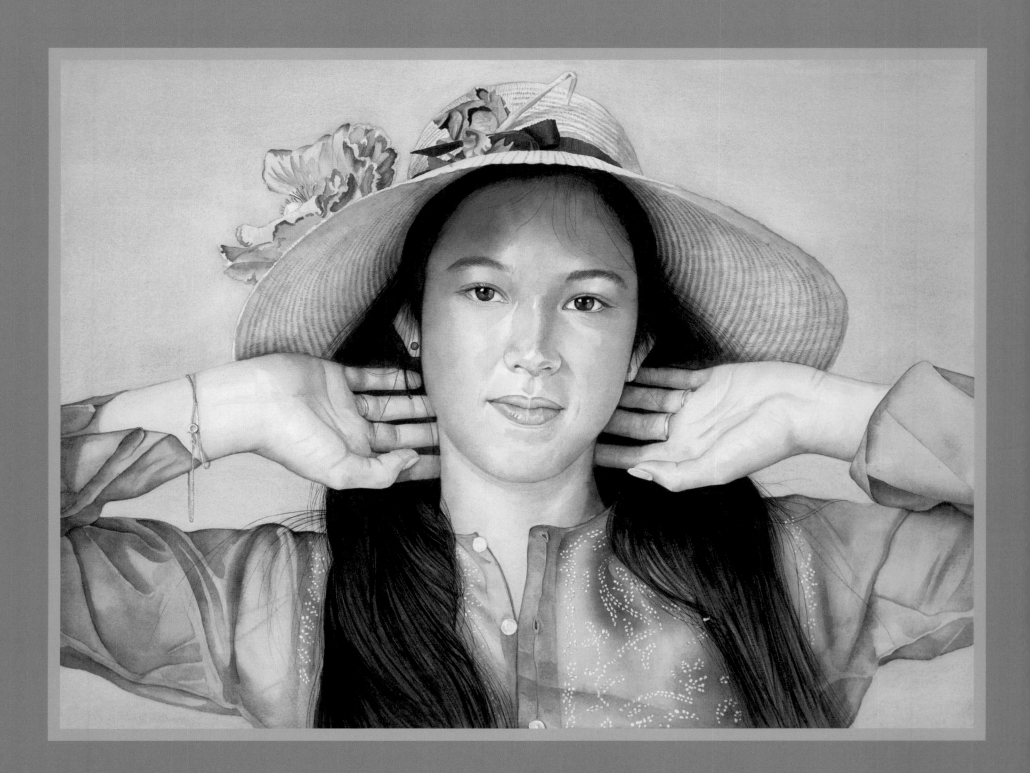

They sit me at my desk and hover over me with wings spread, forming a circle of support. "Every expression, your gestures and responses to others, all that you share from your inner core are a thank you note from your heart, like chicken soup for a sick friend."

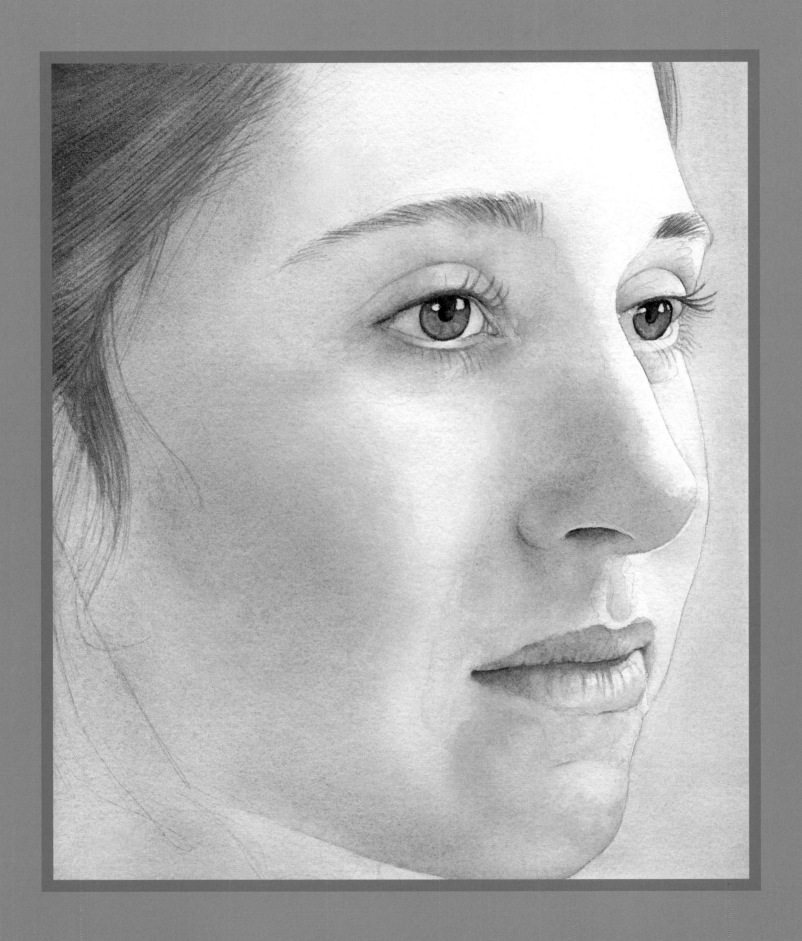

"When you make a gift and give it, you continue an ancient tradition. All things made by hand come by choice from your heart."

Be Wise and Choose the Calmest Road

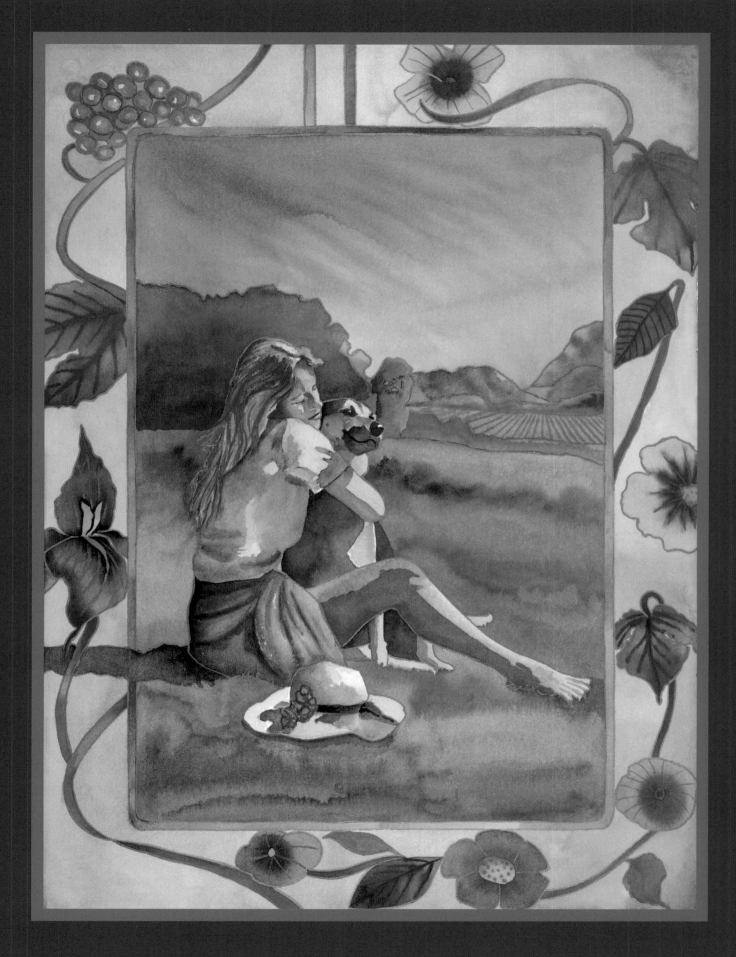

Grace speaks, "This is the hardest request we ask of you." I couldn't imagine what she would say.

"We ask that you choose calm over chaos. When faced with frenzy, we advise you to center yourself on our spirits. Look into our faces and let us help you choose an avenue that will keep you on the peaceful path."

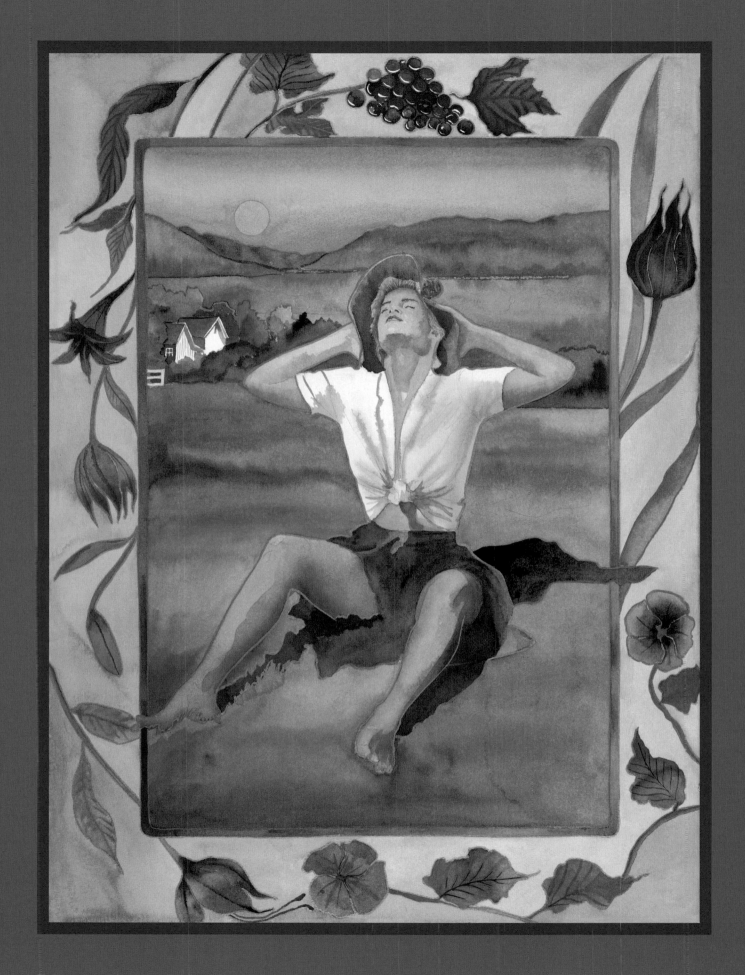

"We all know what it feels like to walk into a place and feel chaos from those around us. It is then that we best go inside ourselves and ask if we want to be in all the disturbance."

"This is your choice of course. We can guide you to our lakes. You must choose to drink the water, calm the heart, still the body, breath deeply and relax."

Letting Go

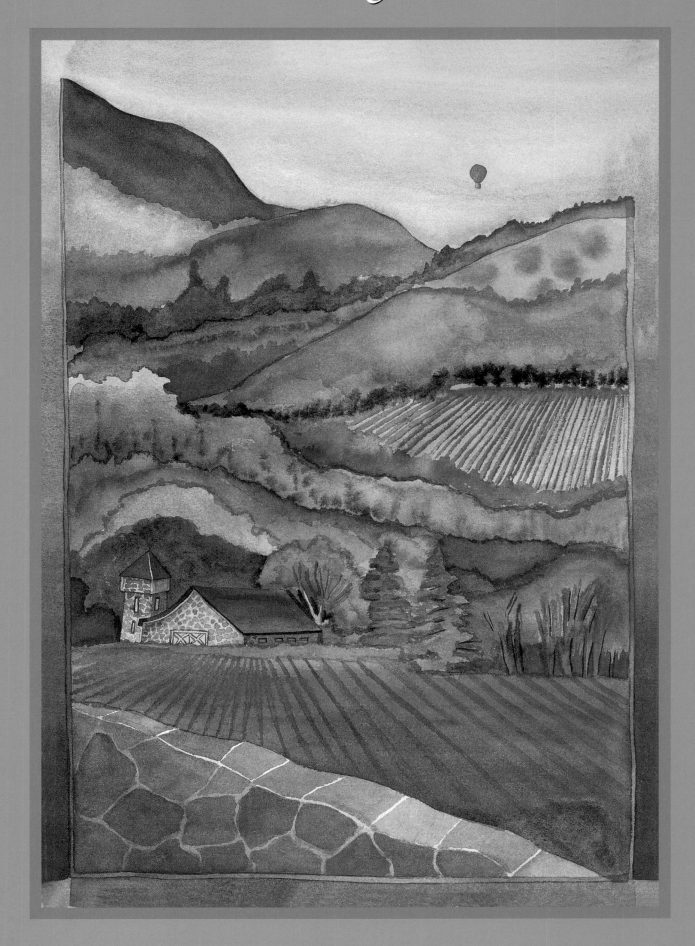

"This journey is almost over for today," they say together. "Don't go. Please," I plead. "We must leave you for this moment, yet understand that life itself is a process of letting go. Inhaling and exhaling, sleeping and waking, opening and closing . . ."

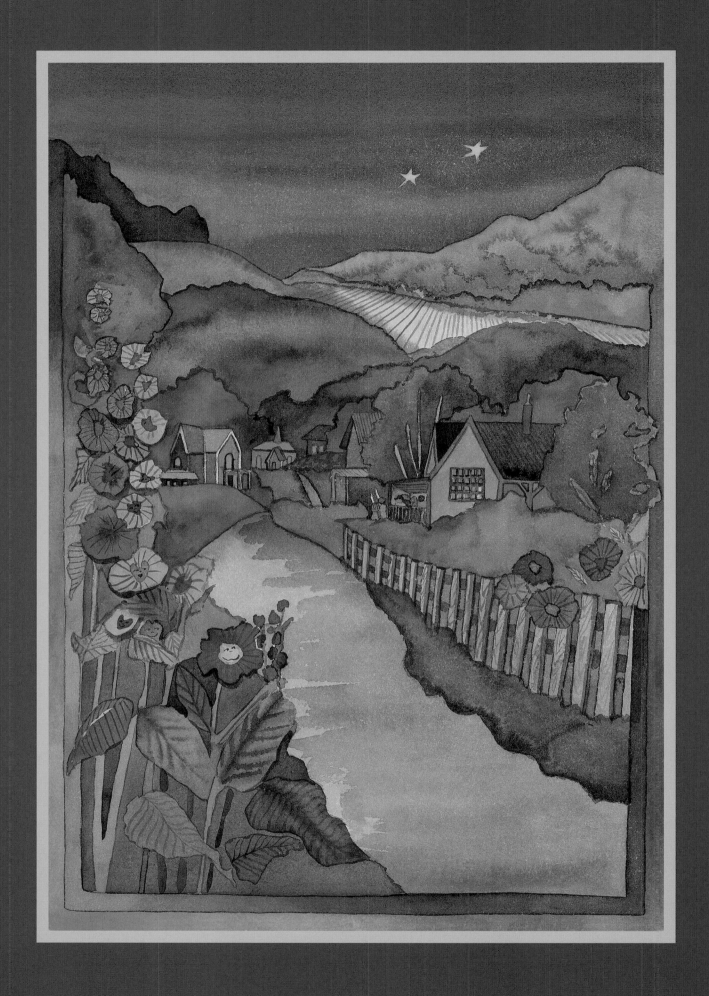

"In death there is great letting go, yet in birth there is also letting go, as a mother releases a child from her womb. Tonight as you slip into dreamland, imagine that tomorrow you will wake as a whole new person with a clean slate. Begin the day by surrendering all the emotional baggage of the day before. Let the morning light and the sounds of the first birds center and place you on a slower, calmer path to the fullness of life. Fear not our child. We are always with you."

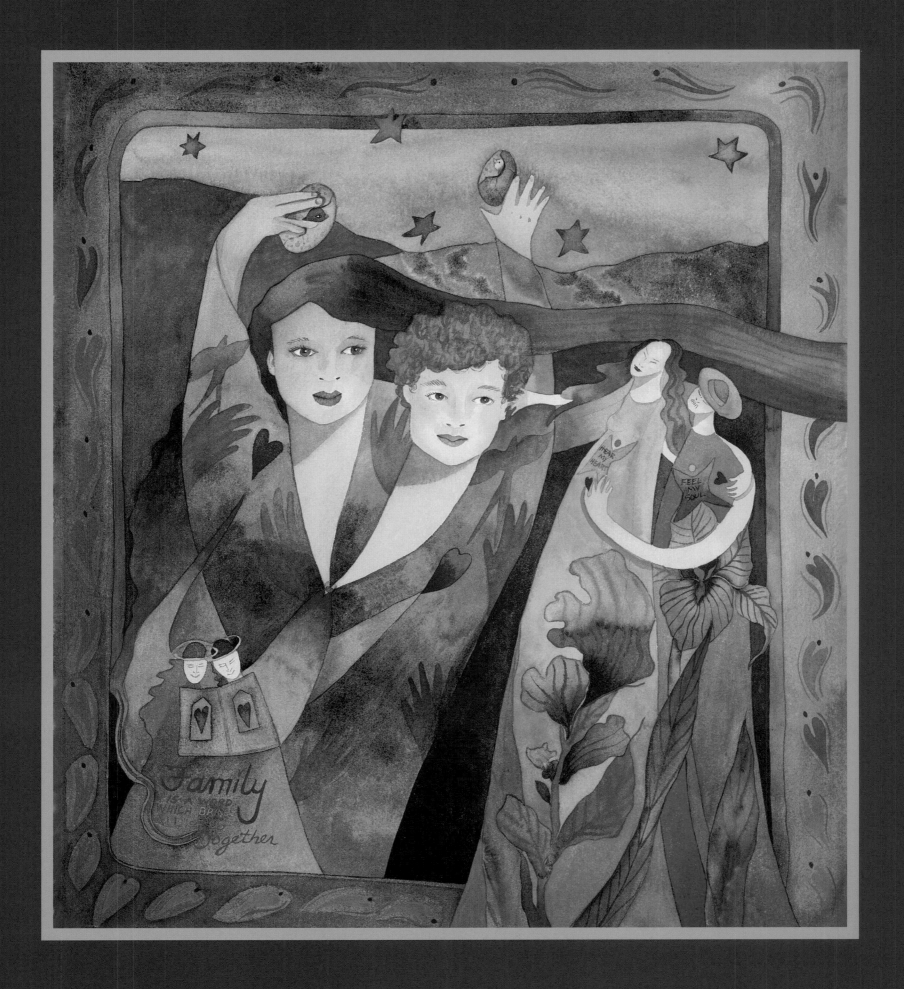

As I watch the world change because of current events, even with all this, my guides stand close and anchor me to my inner beauty, reminding me to honor myself and all those I meet.

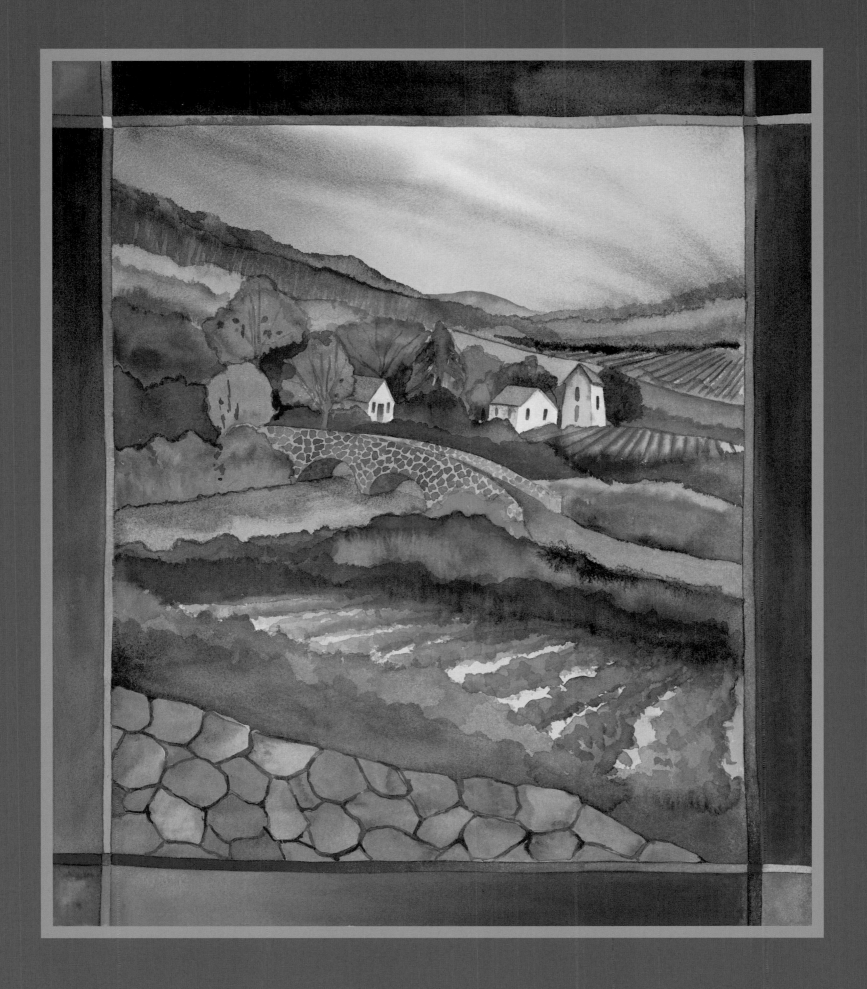

I am humbled and tearful from the wisdom of Angels, Ease and Grace. These two spirits have been there for me through all the roads of my life, even now as I mourn the death of my mother.

Home Within the Heart

I look around and they are gone. At first my heart begins to panic and I fear the return of my speeding self.

Then the butterflies fly past and I hear the comforting coo of morning doves. I relax and trust my new state of mind. I have come a long way in just a few pages in this book. I sit down and take a deep breath. I am home within my heart. My guides, my angels and my mom and dad are always there, whenever I need them.

I am learning that slowing down takes sincere hard work and commitment. It is a lifestyle choice. A friendship choice.

Each day I discover this inner transformation extends to the borders of my body. It is being honest with all those whose path I cross and all those living in my life.

The choice is yours. For now, I choose stillness most of the day and occasionally I choose to dance.

Angel Guidance for Slowing Down

Create a calm atmosphere. Light a candle. Listen to a fountain.
Take a seat on a sofa, in a restaurant or on a park bench.
Allow the sounds to disappear and let your heart open to the rhythms unfolding before you.

From whatever position, slow down. Take three deep breaths. Drop all judgements and listen.
Hear the inner voice speak. Even for just a moment, listen.
Close your eyes and drift deep within.

Mind Intention Meditation

Meditation is the first step to finding peace within.
And only in the stillness seated deep inside can you hear your inner voice.

Make the choice to honor, acknowledge, trust and follow this guidance.
Day by day. Question by question.

Sunsets are a light show to inhale each night with deep long breaths.

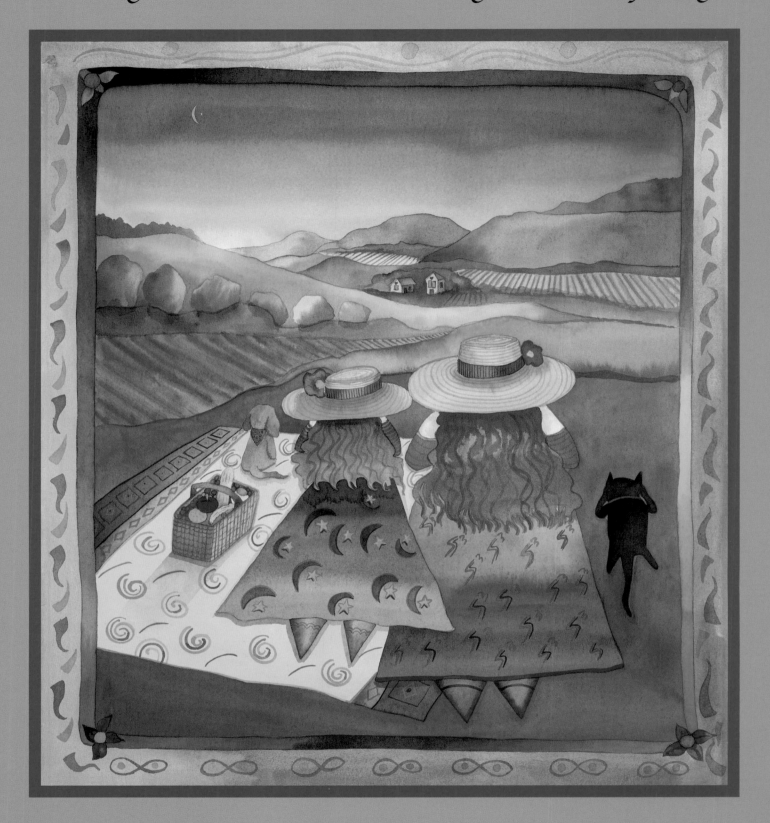

Pink Sprinkle Ceremony

When you sense the need to let go of something, a simple pink sprinkle ceremony
can direct or disconnect the energy around the question or choice.

Imagine glittery pink sprinkles raining down, all imbued with love and goodness.
With clear intent, let go of what you are sprinkling. Shower them on someone you are
honoring, loving, resisting or releasing, and cut the unseen cord.

This is your opportunity to sprinkle good wishes or goodbyes.
This is powerful, healing, star dust delivered and received at will.